NEWCASTLE
HISTORY TOUR

I would like to dedicate the book to my sisters Susan and Christine, and brothers Lawrence and Malcolm.

All the royalties from this book will be divided between St Oswald's Hospice in Gosforth and the Sir Bobby Robson Foundation.

Front cover image shows Newcastle's first Free Library built on New Bridge Street in 1880. Back cover image shows the second Redheugh Bridge built in 1901.

First published 2017

Amberley Publishing
The Hill, Stroud,
Gloucestershire, GL5 4EP
www.amberley-books.com

Copyright © Ken Hutchinson, 2017
Map contains Ordnance Survey data
© Crown copyright and database right [2017]

The right of Ken Hutchinson to be identified as the Author of this work has been asserted in accordance with the Copyrights, Designs and Patents Act 1988.

ISBN 978 1 4456 6674 7 (print)
ISBN 978 1 4456 6675 4 (ebook)

All rights reserved. No part of this book may be reprinted or reproduced or utilised in any form or by any electronic, mechanical or other means, now known or hereafter invented, including photocopying and recording, or in any information storage or retrieval system, without the permission in writing from the Publishers.

British Library Cataloguing in Publication Data.
A catalogue record for this book is available from the British Library.

Origination by Amberley Publishing.
Printed in Great Britain.

INTRODUCTION

Background to the City of Newcastle

Newcastle was established by the Romans in AD 122 when they built a bridge across the River Tyne close to where the swing bridge now stands. It was called Pons Aelius or 'The Bridge of Hadrian'. A fort was built around AD 200 on the top of the hill and a settlement grew up, which remained until around AD 410. It is thought the Roman bridge survived for some time and was eventually replaced by a new structure, which existed before the Norman invasion of 1066. There is evidence of a Saxon settlement called Monkchester on the site of the Roman fort, including a Saxon chapel and cemetery. Robert Curthose, the son of William the Conqueror, built a motte-and-bailey castle on the site of the Roman fort in 1080, which was later rebuilt in stone in the reign of Henry II in 1168–78. The keep still remains as well as the Black Gate and some of the original curtain walls. This is where Newcastle received its present name.

A number of religious institutions set up houses in Newcastle in the early years of Norman rule and the four parish churches were also established over the next few centuries. Dominican Friars set up Blackfriars and there were also White Friars, Grey Friars, Augustinian Friars as well as the Nuns of St Bartholomew, who set up a nunnery.

St Nicholas', St Andrews, St John the Baptist and All Hallows churches were all built to serve the growing population.

Following repeated raids from the Scots, including a number of occupations, Henry III gave consent for Newcastle to build walls around the town. These were commenced in the late 1260s and were not completed until 1313. The walls were over 2 miles long and had seven main gates as well as seventeen water gates leading onto the Quayside; they also had nineteen towers, thirty turrets and a ditch to aid defence. They were used in the Civil War in 1644 and the walls were rebuilt at the time of the Jacobite Rebellion in 1745. Newcastle became an independent county in 1400 under Henry IV apart from the castle precinct, which remained as part of Northumberland.

A medieval bridge was built around 1248 to replace an earlier bridge and had many houses built on it over time. It lasted until 1771, when parts of it were washed away in a great flood. The bridge was replaced by a stone Georgian bridge that was later replaced by the present swing bridge to allow ships to pass up the river to Armstrong's factories. The magnificent High Level Bridge was opened by Queen Victoria in 1849. Other bridges were built over time to give the present famous panorama of seven bridges over the Tyne Gorge.

The settlement originally developed within the town walls around the medieval bridge on either side of the Lort Burn, a steep valley that follows the present line of Dean Street and Grey Street. Sandhill is where the first town hall, the Exchange (now the Guildhall), was built. The Close, Quayside and Pandon areas were densely built up with narrow alleys or 'chares' between them. The main road up from the Quayside followed the line of the present Side Street, below the

castle walls, which led up to Bigg Market and beyond to Newgate. An alternative route to the north was used by pilgrims who crossed the Low Bridge over the Lort Burn and climbed the steep hill past All Hallows Church (now All Saints) leading to Pilgrim Street Gate along the line of Pilgrim Street.

The rest of the town within the walls was dominated by the religious houses, which occupied large areas of land. This all changed under Henry VIII when they were all dissolved and land was sold off for development. The only buildings to survive were at Blackfriars. Anderson Place or Newe House was built on the site of the Greyfriars' friary, to the west of Pilgrim Street. Most of the gates and large sections of wall were removed between 1763 and 1825. A new road, Dean Street, linking the upper town with the Quayside was also built in the late 1700s. In the 1830s the centre of Newcastle was transformed by Richard Grainger. The area, now known as Graingertown, was developed on the site of the former Anderson Place and St Bartholomew's Nunnery to produce the famous Grey Street, Greys Monument, Grainger Street, the Grainger Market and the Theatre Royal.

In 1882 Newcastle became a city. During the 1960s and 1970s, redevelopment had a major impact in the centre of the city in creating the Central Motorway and Eldon Square Shopping Centre. In the 1990s the Quayside area of Newcastle was transformed to introduce such features as the Gateshead Millennium Bridge and the new law courts.

1. CENTRAL STATION, NEVILLE STREET

Opened by Queen Victoria in 1850, the main station was designed by John Dobson with the help of Robert Stephenson; the magnificent curved, glazed roof was the first of its type in the world. It was opened a year after the High Level Bridge was completed to establish the first continuous railway link between London and Edinburgh. The elaborate portico was added later in 1863 and was designed by Thomas Prosser. The station was built over the line of the town walls. One of the original towers, the West Spital Tower, was lost under the present tracks to the east of the main platforms and a further tower, the Stank Tower, was demolished and Neville Street built over it, to the east of the portico.

4. GEORGE STEPHENSON MEMORIAL, WESTGATE ROAD

Often referred to as the 'Father of the Railways', George Stephenson (1781–1848) had this memorial unveiled in his memory in 1862, close to the central station and the Literary & Philosophical Society (Lit & Phil). Together with his son Robert they built many of the world's first railways and also many early locomotives in their locomotive works behind the central station. George also invented a miner's safety lamp, which he demonstrated at the Lit & Phil. It was known as the 'Geordie' lamp and some think this may have led to the name 'Geordies' given to people living in the North East around Newcastle.

5. LITERARY & PHILOSOPHICAL SOCIETY, WESTGATE ROAD

Established in 1793 by Revd William Turner as a 'conversation club', it is the third oldest provincial Literary & Philosophical Society in the country and has the largest independent library outside of London. The present building dates from 1825 and was designed by John Green. It has been a meeting place over the years of many famous people from the region. One of the Lit & Phil's most famous claims to fame is that on 3 February 1879 Joseph Swan demonstrated his incandescent light bulb for the first time and the lecture theatre was lit up, making it the first public building in the world to be lit this way. Today the library is still well used and it continues to hold regular talks and meetings on a wide range of subjects for its members and the wider public.

6. THE MINING INSTITUTE, WESTGATE ROAD

The North of England Institute of Mining and Mechanical Engineers are based in Neville Hall, a building constructed in 1872 and designed by A. M. Dunn. The Mining Institute, as it is known, was set up by mine owners and their engineers to share knowledge and experience to improve safety and efficiencies in their mines. The building houses a magnificent library as well as a lecture theatre and meeting rooms, and over the next few years will see improvements to restore it to its former glory. The building is situated over the line of Hadrian's Wall and there is a plaque on the Westgate Road side to record this.

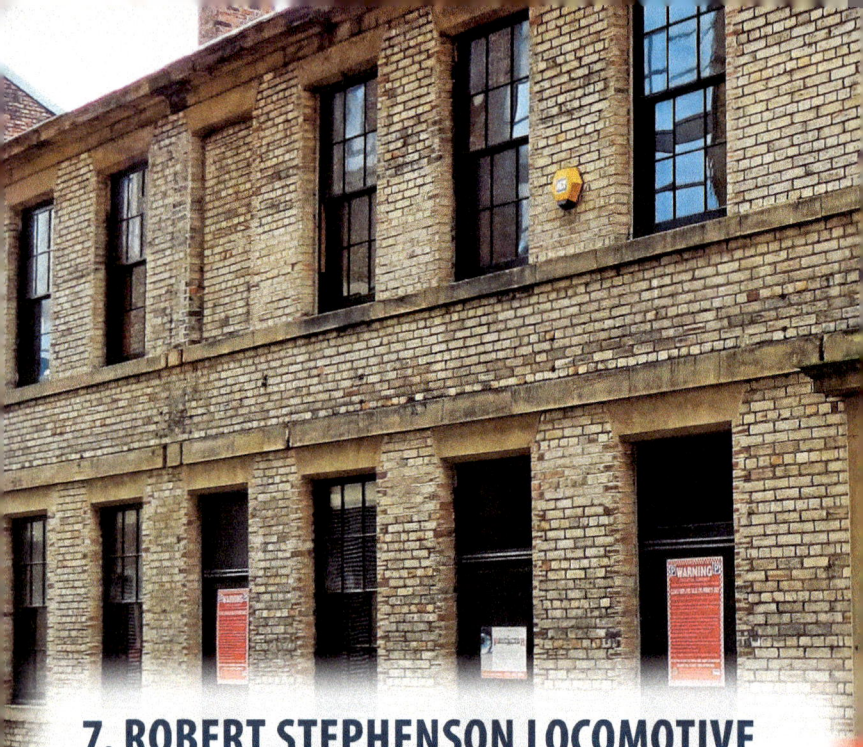

7. ROBERT STEPHENSON LOCOMOTIVE WORKS, SOUTH STREET

This building was part of the first railway locomotive works in the world. Established in 1823, it built and supplied many of the early locomotives that were used to develop early railways in Britain and throughout the world. They supplied locomotives and equipment for the first passenger railway line in the world between Stockton and Darlington in 1825. The famous *Locomotion No. 1* was built here in 1828 (see inset), followed by *Rocket* in 1829. It was named after George Stephenson's twenty-year-old son Robert, who went on to become famous in his own right in later years as a railway engineer and bridge builder.

8. WHITE FRIARS TOWER & TOWN WALLS

White Friars Tower was named after the Carmelite monastery that existed nearby at the time the walls were constructed in the late thirteenth century. The monks wore white robes and were referred to as the White Friars. Traces of their monastery were located during excavations in the 1960s under Forth Street. The tower was located at the top of the steep slope leading down to the river and the path, which later became Hanover Street, cut through the wall below the tower. The tower itself was demolished around 1844. The castle keep can be seen in the distance.

9. TOWN WALLS, ORCHARD STREET

These impressive sections of town wall are almost full height and have only been visible relatively recently. For many years they were hidden within the Federation Brewery, which preserved them from destruction, apart from when an internal alteration drove a hole through the wall to connect brewery buildings. The last time these walls were breached was during the Scottish siege of Newcastle during the Civil War in 1644, when part of the wall was tunnelled under and blown up. The walls were rebuilt during the Jacobite Rebellion in 1745 and later incorporated into adjoining buildings. The land outside the walls was used as an orchard in medieval times.

10. HIGH LEVEL BRIDGE & BRIDGE INN

The High Level Bridge was designed by Robert Stephenson and opened in 1849. It was the first double-decked bridge in the world, with a road under the railway deck. The entrance to the bridge at this point was dominated for many years by the presence of an original locomotive situated on the bridge structure. The engine was known as *Billy* or *No. 1 Engine* and was built at Stephenson's nearby locomotive works. The Bridge Inn took its name from the bridge and was built on the line of the original castle walls, which can be seen immediately to the south. It was later rebuilt in 1901 and over the years has been a popular venue for live music.

11. CASTLE KEEP BUILT ON THE ROMAN FORT OF PONS AELIUS

In 1080 Robert Curthose, the son of William the Conqueror, built a timber motte-and-bailey castle on the site of the earlier Roman fort of Pons Aelius. A century later Henry II built a stone castle on the site and the present keep was built over the original headquarters building of the Roman fort. When standing to the south-west of the keep, paving stones that mark out the outline of the headquarters building can be seen as it disappears under the keep. Other Roman buildings are marked out and include the two granaries and part of the commanding officers house. The keep has had many uses and was used as a prison for many years before it was restored in 1810, when Newcastle Corporation bought it and built up the battlements to make it look like a 'proper castle'. The railway companies demolished a lot of the castle walls but the keep survived after a fight by antiquarians from the Newcastle area.

12. CASTLE GARTH

The narrow street leading from Castle Steps to the Black Gate was known as Castle Garth and is seen here in the late 1890s.

13. CASTLE STEPS

In 1904 shops occupied the side of Castle Stairs, leading from the castle and down the steep bank to the Quayside. The steps passed through the postern gate in the castle's curtain walls that still exists today. The shops have all been cleared away to expose a long expanse of the curtain wall leading west towards the High Level Bridge where it turns northward behind the Bridge Hotel.

14. MOOT HALL

The present Moot Hall, seen here in the 1930s, was built in 1810 and designed in the Greek revival style by William Stokoe. It replaced the ancient Castle Great Hall or Moot Hall that stood on the site of the present Vermont Hotel. Lawbreakers from within the castle walls and in Northumberland were tried at the assizes court in this building and, if found guilty, were gaoled in the keep. The new Moot Hall became the Northumberland County Court and remained so until the 1980s when the new law courts on the Quayside were built in 1990. It is still used as a Crown Court.

15. SAXON CHURCH & RAILWAY ARCHES

After the Roman occupation ended in AD 410, a Saxon settlement developed around the former Roman fort of Pons Aleius and was called Monkchester. This would suggest that it was occupied by a monastery for some time. Excavations carried out in the 1990s found the remains of what is believed to be a Saxon church or chapel under one of the railway arches that carries the Victorian railway right through the original castle walls, separating the keep from the Black Gate. At the same time over 600 Christian burials were found in the area surrounding the chapel, confirming there was a large cemetery on the site of the former Roman fort. The walls of the former chapel are on display under the arch close to where the lines of walls of the former Roman structures are marked out by paving.

16. BLACK GATE

The present museum building started life as a bastion gate to the original north gate of the castle. It was built in 1270 and got its name from a tenant called Patrick Black.

17. ST NICHOLAS' CATHEDRAL

The present building dates from the fourteenth and fifteenth centuries, with the magnificent lantern tower dating from around 1448. It was the largest parish church in Newcastle and in 1882 it became one of the smallest cathedrals in the country when Newcastle became a city.

18. LOW BRIDGE

The Low Bridge was situated on Dean Street close to the steps leading to St Nicholas' Cathedral. Dean Street was built in the late 1700s over the former Lort Burn that flowed in a steep-sided valley that was a major obstacle to both vehicular and pedestrian traffic moving from east to west across Newcastle. High Bridge was built further up the valley. The Low Bridge was also known as Nether Dene Bridge, seen here in 1780 shortly before it was demolished, and gave pedestrian access to the foot of Pilgrim Street close to All Saints church.

19. SIDE AND DEAN STREET

Side is the ancient route from Newcastle Bridge up to the castle, cathedral and Bigg Market. It climbs steeply past the site of the birthplace of Admiral Cuthbert Collingwood, the victor of the Battle of Trafalgar, now marked on Milburn House by a blue plaque and bust of the famous seafarer. Dean Street was designed by architect and town planner David Stephenson and built by Newcastle Corporation to provide a commodious bypass to Side. The new thoroughfare provided a wide access road up to the higher plateau above the Quayside and, at the same time, removed the unhealthy and disgusting open sewer that the Lort Burn had become. The Low Bridge was swept away and a new east–west street, Moseley Street, was built to form a T-junction with Dean Street, and vehicular access to Pilgrim Street to the east and St Nicholas' Church to the west.

20. SANDHILL

As its name suggests, the area to the east of the original Tyne Bridge was a hill of sand, probably deposited on the banks of the Tyne by the Lort Burn. This area became a centre for markets and later administration when the Exchange, or Guildhall, was built on the site. Merchants wanting to live in the area built houses overlooking Sandhill close to the bridge and backing onto the steep slopes of the castle as well as on both side of Side as it progressed up the hill. Many fine merchant houses were built during medieval times and some have survived such as Bessie Surtees House, now occupied by Historic England. Unfortunately the great fire of Gateshead and Newcastle in 1854 destroyed all these buildings to the east of Sandhill as far as the Custom House on Quayside.

21. GUILDHALL

The present Guildhall building looks completely different. The large structure to the left was built in 1425 as St Catherine's Hospital for the poor. The Exchange building to the right acted as a town hall, meeting rooms for the Guilds and courtroom (which still survives intact).

22. MEDIEVAL BRIDGE

The medieval bridge, seen here around 1750, was erected around 1248 on the site of the original Roman bridge. Over time a number of buildings were built on the bridge itself. At the Newcastle end of the bridge there was a chapel to St Thomas à Becket. The bridge was destroyed during the great flood of 1771 when large sections were washed away.

23. GEORGIAN BRIDGE

All the bridges on the Tyne, with the exception of Corbridge, were swept away during the flood of 1771 and the former medieval bridge was eventually replace in 1781 by a new elegant stone-built bridge. It was known for some years as Mylne's Bridge after J. Mylne, who oversaw its construction. It was built on the line of the original Roman and medieval bridges and was 91.5 metres long, attractively built in stone with nine arches and a decorative balustrade over the arches. Only smaller vessels such as keelboats could pass under the arches, by lowering their sails, from the higher reaches of the Tyne. The bridge lasted less than 100 years before it was replaced by the present Swing Bridge in 1876 to allow large vessels to pass further upriver.

24. SWING BRIDGE (WITH HIGH LEVEL BRIDGE)

The Swing Bridge was designed by William Armstrong using hydraulic machinery to turn the bridge to allow large ocean-going vessels to gain access to his armament factories upstream. When it was built, it was the biggest turning bridge in the world. It replaced the former Georgian bridge, which proved a major obstacle to shipping. At one time the bridge used to open several times a day but now it rarely opens except for regular maintenance purposes. In 1924 it opened to allow 6,000 ships through in what was its busiest year. While it was being constructed, a temporary bridge was put in place from 1865–76. The Swing Bridge was opened on 25 June 1876 and is the only bridge out of the seven across the Tyne Gorge not to have been opened by royalty.

25. TYNE BRIDGE UNDER CONSTRUCTION

In 1928 the Tyne Bridge was under construction in advance of the formal opening by George V on 10 October that year. It was built out from both banks to avoid disturbing the river traffic movements below. Once the two sides of the arch met mid-river the road deck was suspended from it. The four towers are purely decorative and were designed as warehouses with lifts inside. They have never been used as warehouses but the lifts were used for a number of years by pedestrians moving between the bridge and the riverside.

26. ALL SAINTS CHURCH

One of the original four parish churches in Newcastle, the former All Hallows Church was replaced by the present All Saints Church in 1796 after it suffered from subsidence and could not be repaired. David Stephenson was the architect who designed the striking elliptical church with a magnificent 200-foot tower and steeple.

27. TRINITY HOUSE

Trinity House was established in the early sixteenth century for the Newcastle Company of Mariners and given a royal charter by Henry VIII in 1536. Trinity House oversaw improvements on the River Tyne to ensure that vessels could reach the port of Newcastle to unload goods at the busy Quayside. They were allowed to charge a toll from ships using the river and this was invested in carrying out improvements along the river as well as for paying taxes to the king. Over time they removed sandbanks, dredged parts of the river and erected lighthouses at the mouth of the river at North Shields. Later they became responsible for the coastline from Berwick to Whitby. As well as a main administrative building, they also built a school to train and examine mariners and pilots as well as a chapel (see inset) and almshouses. Parts of the courtyard complex of buildings date to medieval times with later eighteenth-century meeting rooms and almshouses; the entrance stairway dates from around 1800.

28. KEELMAN'S HOSPITAL

The Keelmen of Newcastle built this hospital in 1701 for their fellow sick and aged workers and their families, with contributions made through a levy on each load of coal or other goods they were paid for. This was a unique arrangement among the working class, who could not rely on a welfare state or wealthy benefactors to look after them in hard times. The building was erected in the Sandgate area close to where the Keelmen traditionally lived in a close-knit community, who had a tradition of hard work and looking after each other. At the time it was built the Keelmen were mainly employed in transporting coal from upriver of the Newcastle Bridge to Collier Briggs at the river mouth. The buildings continued to provide social housing long after the Keelmen disappeared from the river. The building was last used as student housing in the 1990s.

29. SALLYPORT TOWER

This tower is sometimes called Wall Knoll Tower and is the only surviving town wall gate, although it is not a main gate but a postern or minor gate. Defending troops could sally out from this gate to attack the enemy, which gives it the name Sallyport. The tower and gate were originally built between 1299 and 1307. This was after a decision was taken to extend the town wall around the Pandon area, which was not included in the original plans. In 1716 it was rebuilt by the Company of Shipwrights as a meeting hall and the original medieval gate was greatly enhanced with the building of an impressive square hall with large glazed windows and corner turrets. It became known as Shipwrights' or Carpenters' Tower before becoming the Sallyport Tower and has had various uses over the years including as a Wesleyan Methodist Girls' school, for furniture storage, as meeting rooms and for private parties.

30. HOLY JESUS HOSPITAL

The Freemen or Holy Jesus Hospital was built in 1681 on the site of a former medieval Augustinian friary. The hospital was built to house Freemen of Newcastle and their widows and unmarried daughters. To the west is a sign on the building to say that it once housed a soup kitchen for the poor in 1880. After the Dissolution of the Monasteries in 1539, the king retained parts of the Augustan friary as his manor and the area was referred to from then as 'Manors'. The building was used as the headquarters of his 'Council of the North' until 1639.

HOLY JESUS
HOSPITAL
NEWCASTLE

31. ROYAL ARCADE, SWAN HOUSE

The Royal Arcade, built in 1832, was the first indoor shopping centre of its type in Newcastle. It was constructed by Richard Grainger, designed by John Dobson and stood on Pilgrim Street under the present Swan House, and it was demolished to make way for the motorway. It was considered to be one of the best, if not the finest, arcades in the country at the time and held sixteen shops, together with banks, offices, a post office and steam bath. It was lit from above by eight skylights set in domes, highlighting the decorative stonework and black marble chequered floor. It was never a commercial success as it was at the wrong end of town away from the Graingertown area developed in the 1840s. A replica of the interior of the Royal Arcade was built under Swan House and parts of the decorative ceiling can now be seen within the restaurant on the site.

32. NEWE HOUSE/ANDERSON PLACE

Anderson Place, seen here in 1702, was a large house and gardens erected on land formerly owned by St Bartholomew's Nunnery and occupied by the Franciscan's Friary, and it was given to the Anderson family following the Reformation in 1539. It was known as the Newe House. The land was bought in 1834 by Richard Grainger, who developed his Graingertown on the site. Charles I was held prisoner in Anderson Place between 1646 and 1647 during the Scottish occupation of Newcastle.

33. PILGRIM STREET GATE, BLACKETT STREET

Pilgrim Street Gate stood on the junction of Blackett Street and Pilgrim Street on the south side opposite Northumberland Street. The roads follow the line of Pilgrims Way heading to Barras Bridge on the way to St Mary's Shrine in Jesmond. It is seen here in 1786 before it was demolished in 1802 to improve traffic flows. The gate had been altered over time and the large windows were installed when it was converted for use as a meeting room for the Joiners Co. or Guild. The two side pedestrian gates were also a later addition to ease pedestrian access to the town.

34. NORTHUMBERLAND STREET

Northumberland Street in 1917 was relatively quiet, with shops on the ground floor and residential accommodation above on two floors. This all changed in 1928 when the new Tyne Bridge was built, which brought all the through traffic using the Great North Road directly on to Pilgrim Street and continued up Northumberland Street heading north. This conflict between shoppers and traffic continued until John Dobson Street was built in the 1970s. The large white building on the left is Fenwick's, which was established by John James Fenwick in this building in 1855 and is one of the oldest family businesses in Newcastle.

78367 JV

35. GREY'S MONUMENT

The monument and statue was erected in 1838 to honour Charles Grey, who is known throughout the world for giving his name to Earl Grey tea rather than being the former British prime minister who was responsible for changing the democratic makeup of Britain by introducing the Great Reform Act of 1832. The unique tea was blended with bergamot oil to offset the high level of lime in the local water supply at his home of Howick Hall in Northumberland and became popular with guests at No. 10 Downing Street. Earl Grey's Monument lost its head in 1941 after it was struck by lightning during the Second World War, and it was replaced in 1947. It is possible to climb the 164 steps up to the top of the monument to gain a spectacular view of the city. Newcastle City Guides arrange openings during the summer months on certain days, details of which can be found on its website: www.newcastlecityguides.org.uk.

36. ELDON SQUARE

This fine square of houses, overlooking a private garden, was built by Richard Grainger to the design of John Dobson in the early 1820s. They were built north of the town walls that followed the line of Blackett Street, which were demolished around the same time. By the 1960s the former grand houses had been subdivided, were poorly maintained, and had a shabby appearance. A new shopping complex was proposed at this time and only the east terrace was retained when the new Eldon Square Shopping Centre was developed in the 1970s – both the north and west terraces were lost.

37. GRAINGER MARKET

The Grainger Market was built by Richard Grainger in 1835 to replace the earlier Flesh Market, situated on the site of the present Grey Street, and took only eighteen months to build. When it opened, there was a public dinner for 2,000 male guests on Thursday 22 October 1835 and a further 300 ladies were seated on a specially erected balcony to witness the celebrations. At first it was mainly occupied by butchers and originally there were 180, with some fruit and vegetable traders. The cellars underneath were used to store the meat as it was cooler. The original Marks & Spencer Penny Arcade, dated 1895, is now the oldest Marks & Spencer shop in the country. The General Weigh House was originally there to weigh meat as it arrived in the market. In recent years it has been used to weigh people and has been very popular, with up to 1,000 customers using it on a Saturday.

38. CENTRAL ARCADE

The original triangular-shaped building was built by Richard Grainger in 1837 and designed by Walker & Wardle. Grainger wanted it to be the town's Corn Exchange, but the Newcastle Corporation had other ideas and Grainger opened it as a popular newsroom and exhibition area with 1,600 members. It was later refurbished to include a reading room, art gallery and concert hall to hold 1,000 people. Later it became a Vaudeville theatre in 1897. On the south side facing Market Street, a fifty-bedroom hotel was built called the Central Exchange Hotel. The Central Arcade is unique in Newcastle as it is the only Edwardian purpose-built shopping arcade and retains many of its original features, not least the magnificent Bermontoft Tiles dating from 1906, installed after a major fire in 1901. Windows' music and instrument shop has been here since it became a shopping arcade.

39. GREY STREET

Grey Street was originally designed as the main street through Newcastle linking with Dean Street and was built on a grand scale accordingly between 1834 and 1837. Grey Street follows the curve of the Lort Burn that is in a culvert below the street. Before it was filled in the valley of the Lort Burn was like an open sewer where all manner of waste was thrown, not least from the butchers on the Flesh Market. The east side was designed by John Dobson and the west by Wardle & Armstrong in what has been described as in 'Tyneside Classical' style. Most buildings have four generous stories above ground and three below. The grandest structure is the former Bank of England building on the west side, built in 1835 and used by the bank until 1968. The street has had many admirers over the years, including the British buildings expert Nicholas Pevsner. It was voted the best Georgian street in England by Radio 4 listeners in 2002.

40. THEATRE ROYAL, GREY STREET

The Theatre Royal is the finest building on Grey Street and was built to impress as a landmark building with its magnificent portico with six vast columns topped by Corinthian capitals and decorated pediment above, projecting out into the street itself. It was built to replace the existing Theatre Royal on Mosley Street, built in 1788, and took only six months to build. It was started in July 1836 and opened in February 1837. The first production was *The Merchant of Venice* by William Shakespeare. It was designed by John and Benjamin Green. Above the pediment is the base of a pedestal for the statue of Mrs Siddons (as 'The Tragic Muse'), which never arrived. In 1899 a fire badly damaged the theatre and Frank Matcham, the famous designer, redesigned the interior to a very high standard. In recent years the interior has been refurbished back to the original designs of Matcham.

41. BIGG MARKET

The Bigg Market, which was named after a form of barley, originally fronted the parish church of St Nicholas and was one of the original medieval market places together with the Groat Market and Cloth Market. It had many burgage plots leading off it, such as the one containing the Old George, one of Newcastle's oldest pubs. In 1854 the town hall was built opposite St Nicholas', adjoining the earlier Corn Exchange built here in the 1830s. The impressive clock tower had to be demolished in the 1930s and the main building was demolished in the 1970s.

42. NEWGATE

The Newgate, seen here in 1781, was one of the largest and probably the strongest gate built on Newcastle town walls. As it faced north, it was the first gate to be seen by the old enemy, the Scots, and like the Westgate it had a bastion built onto it. It was so big and strong that it later became the town's gaol and was used as this from around 1400 until 1823. A new prison was built at Carliol Square, opening in 1828. Newgate Prison held prisoners for the town of Newcastle and those condemned to die were taken out and hung at nearby Gallowgate. The Newgate was demolished in 1824 to improve traffic flow as well as help the town extend beyond the walls. The road inside the gate is still called Newgate Street. The town wall can be seen behind St Andrew's Church.

43. ST ANDREW'S CHURCH

St Andrew's Church is said to be the oldest in Newcastle, dating from the twelfth century, and the tower includes Roman stones. Some think the church was paid for by David, king of Scotland, while he ruled Northumberland from 1139 to 1157 and was based in Newcastle. John Wesley preached in the church a number of times and praised the congregation as the best behaved he had preached to in his travels. In 1650 there were fifteen witches buried in an unconsecrated part of the graveyard. The outdoor market on Newgate Street was the original Green Market, which later moved to covered accommodation.

44. TOWN WALLS & HERBER TOWER

The town walls to the west of St Andrew's Church are the longest and best-preserved sections of walls in Newcastle. They start at the remains of the Ever Tower and carry on westwards past the well-preserved Morden Tower, which was used for many years for poetry meetings. The remnants of a turret are clearly visible on this section as well as a doorway that the monks of Blackfriars used to reach their orchard. There is a wide ditch parallel to the walls along this section to represent the position of the original ditch, which was much larger when used to defend the walls. The almost intact structure of the Heber Tower turns the corner and the walls continue down Bath Lane past the Durham Tower to where the Westgate formerly stood.

45. BLACKFRIARS

The Blackfriars came to Newcastle in 1239 and were given land in the western part of the town, and they built a church and buildings on the present site. The Blackfriars regularly entertained royalty and in 1322 Edward II and his wife Isabella had a fortnight's holiday there. Henry VIII had the church pulled down and the buildings were passed to the Newcastle Corporation, who let them out to nine of the town's guilds and occupied the buildings for centuries – the Smiths still occupy part of the site. The buildings fell into disrepair during the twentieth century but were rescued and restored in the 1970s.

46. WEST GATE

The West Gate was situated on the West Road on the line of the ancient road following the route of Hadrian's Wall. It was one of only two gates to have a bastion in front for added strength. Prisoners from Northumberland, held in the castle keep, were brought to gallows outside the West Gate to be hung. Westgate was pulled down in 1811 to improve traffic flow as it had become a bottleneck.

47. ST MARY'S CATHEDRAL

The cathedral was originally built in 1844 as a Roman Catholic parish church and designed by A. W. N. Pugin, who also designed the Houses of Parliament. It became a cathedral in 1850. To the rear is a remembrance garden to Cardinal Basil Hume, which was formerly opened by the Queen in 2002. Cardinal Basil Hume was born George Hume in Newcastle in 1923. He started his religious life as a Benedictine monk, rising to become abbot at Ampleforth. He then progressed to become Cardinal Archbishop of Westminster, the head of the Roman Catholic Church in England. He retained his lifelong affection for Newcastle and was also a great follower of Newcastle United. His statue is seen in his Benedictine habit, standing on a representation of holy island or Lindisfarne, with boulders from the island as well as a stone from Ampleforth. He is said to have taken inspiration from such saints as St Cuthbert and St Aidan.

48. THE INFIRMARY

The Infirmary, seen here around 1906, was built in 1752 on the Forth Banks to the west of the present Central Station on the site of the present Centre for Life. It was built by public subscription mainly for the poor. It opened with ninety beds and employed two surgeons. In 1760 two further surgeons were employed and it was extended in 1855 to deal with a large increase in patients. The railway encroached on its grounds and immediately behind the Infirmary was the Cattle Market – not an ideal neighbour. The Royal Victoria Infirmary was built as a replacement in 1906 beside the Town Moor but the buildings remained until 1954.

ACKNOWLEDGEMENTS

Special thanks go to Sarah Mulligan and the staff at Newcastle City Libraries for allowing me to use the excellent pictures and photographs from their impressive collection.

Thanks to my wife Pauline for proofreading the book. Thanks to the team at Amberley for asking me to write the book and for helping me to produce it. Thanks to all the City Guides for sharing their knowledge and also for sharing their enthusiasm and encouragement to promote our special city or 'toon' of Newcastle. Special thanks go to my wife Pauline, sons Peter and David and granddaughter Isla for their continued support and encouragement.

I was asked to write this book following the success of writing earlier 'History Tour' books on Wallsend and Tynemouth & Cullercoats in addition to two books on Newcastle, namely *Lost Newcastle in Colour* and *Secret Newcastle*. This book aims to give readers a brief introduction to the history of Newcastle and will hopefully encourage them to read more widely on the subject of this fascinating city. The book is pocket sized and hopefully will encourage the reader to walk around the city to identify the locations of the former town gates, walls and former Roman and religious sites. In addition many older buildings still survive within the original walled town including large sections of town walls, towers and turrets, the Norman castle keep, the

medieval Blackfriars, the four original parish churches (St Nicholas' is now the cathedral), many other interesting buildings as well as the magnificent bridges over the Tyne. I am a Newcastle City Guide and each year the guides undertake over forty different guided walks in Newcastle and surrounding towns including Wallsend, Tynemouth and Cullercoats. Details of all walks can be found on the Newcastle City Guides website www.newcastlecityguides.org.uk.

As with any book of this type there will inevitably be some errors for which I apologise in advance as I have not been able to check every name, date or detail at the original source.

Also Available from Amberley Publishing

SECRET NEWCASTLE

KEN HUTCHINSON

This fascinating book explores Newcastle's lesser-known history.

Paperback
96 pages
978-1-4456-4127-0

Available from all good bookshops or to order direct
please call **01453-847-800**
www.amberley-books.com